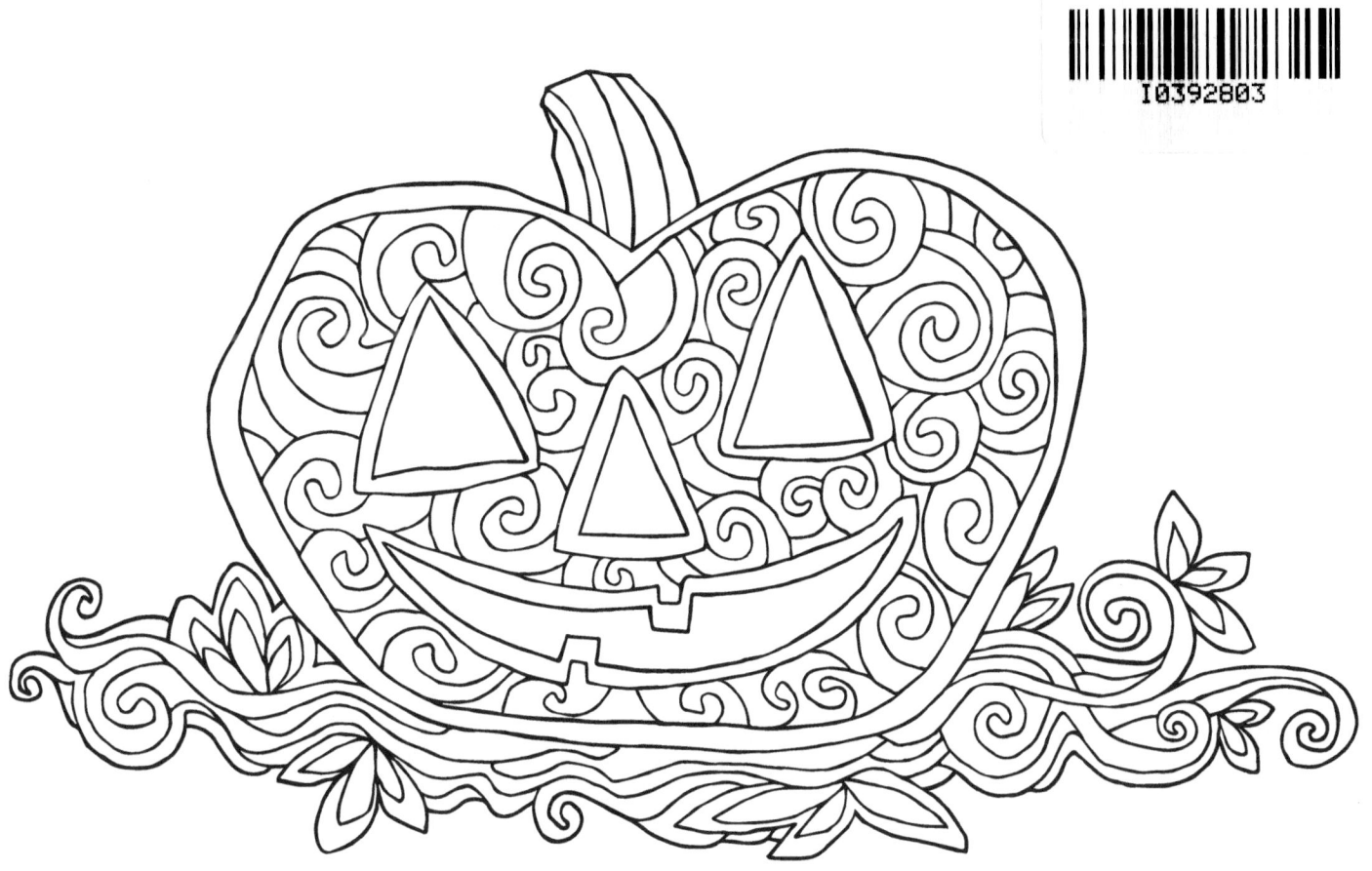

COLOR LAND
CREATURES

A coloring book for creature colorists of all ages.

Original drawings by Steve Vistaunet

Directions: Add color as desired.
If you are using markers, you will want to put a piece of scrap paper between the pages while you color.

All rights reserved. No part of this book may be reproduced or transmitted in any form or by any means, electronic or mechanical, including photocopy, or any information storage and retrieval system, without prior written consent from the author.

Color Land Creatures Coloring Book
©2016 A Happy Vista
Provo, Utah 84604

www.ahappyvista.com

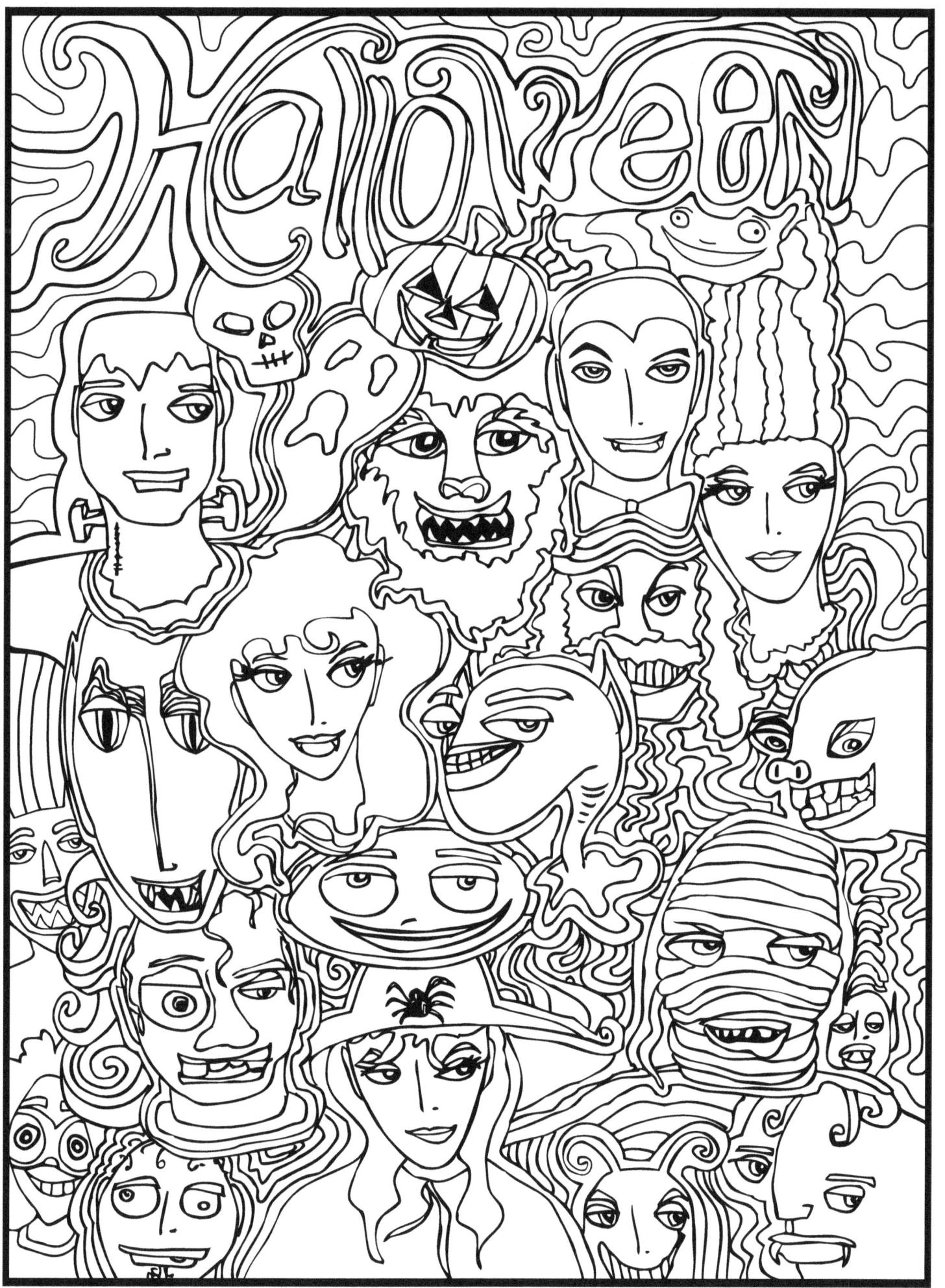

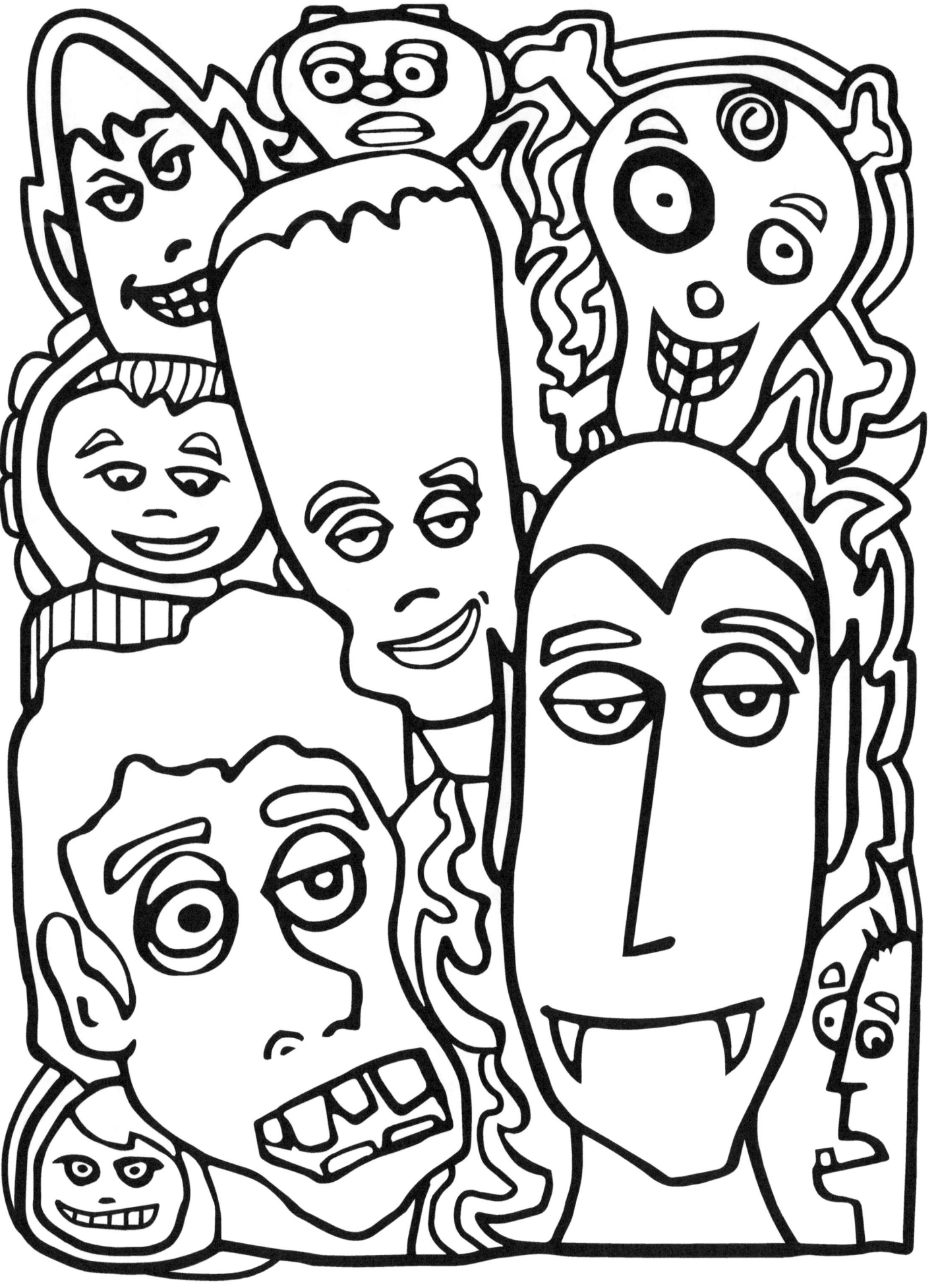

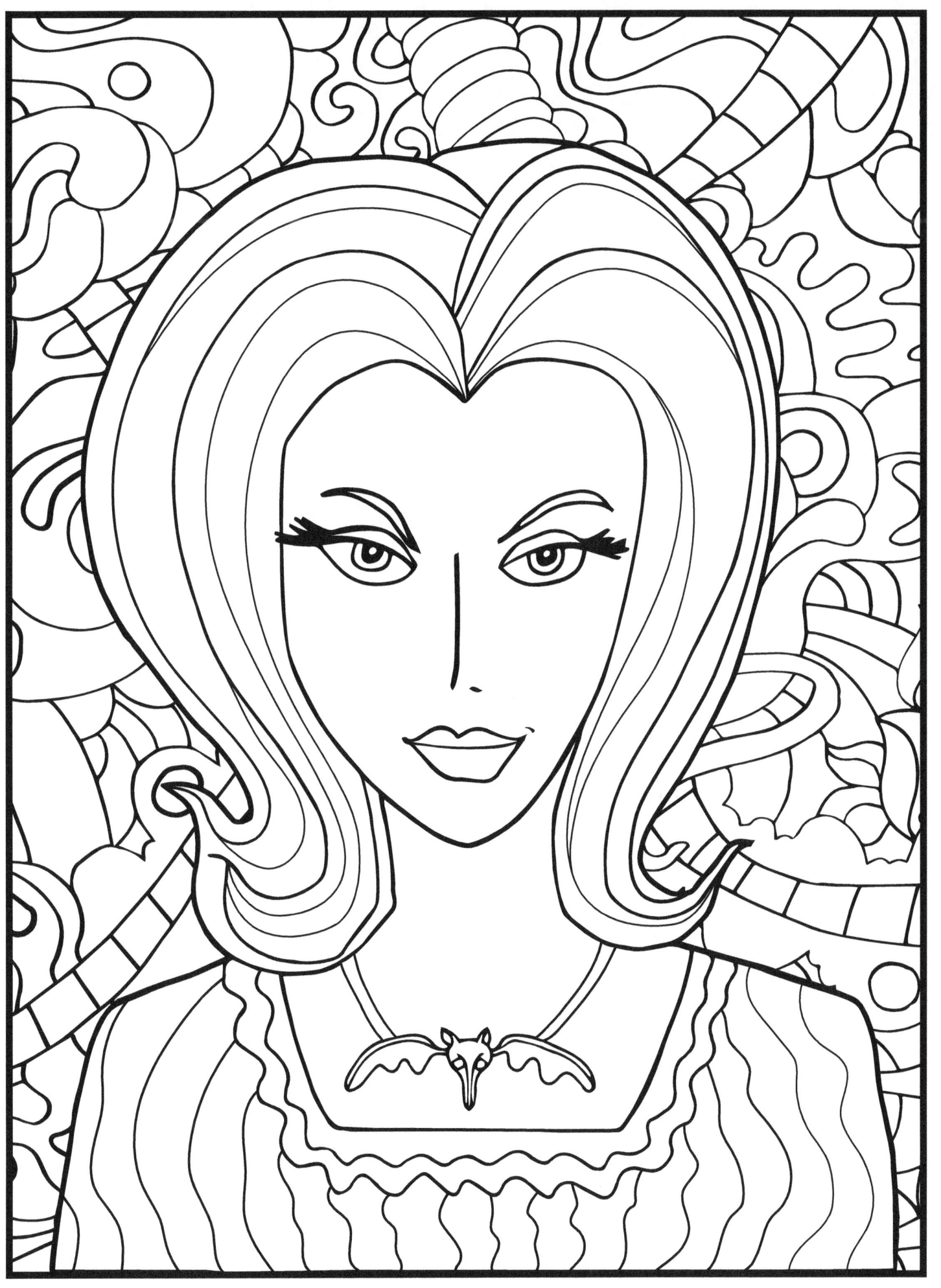

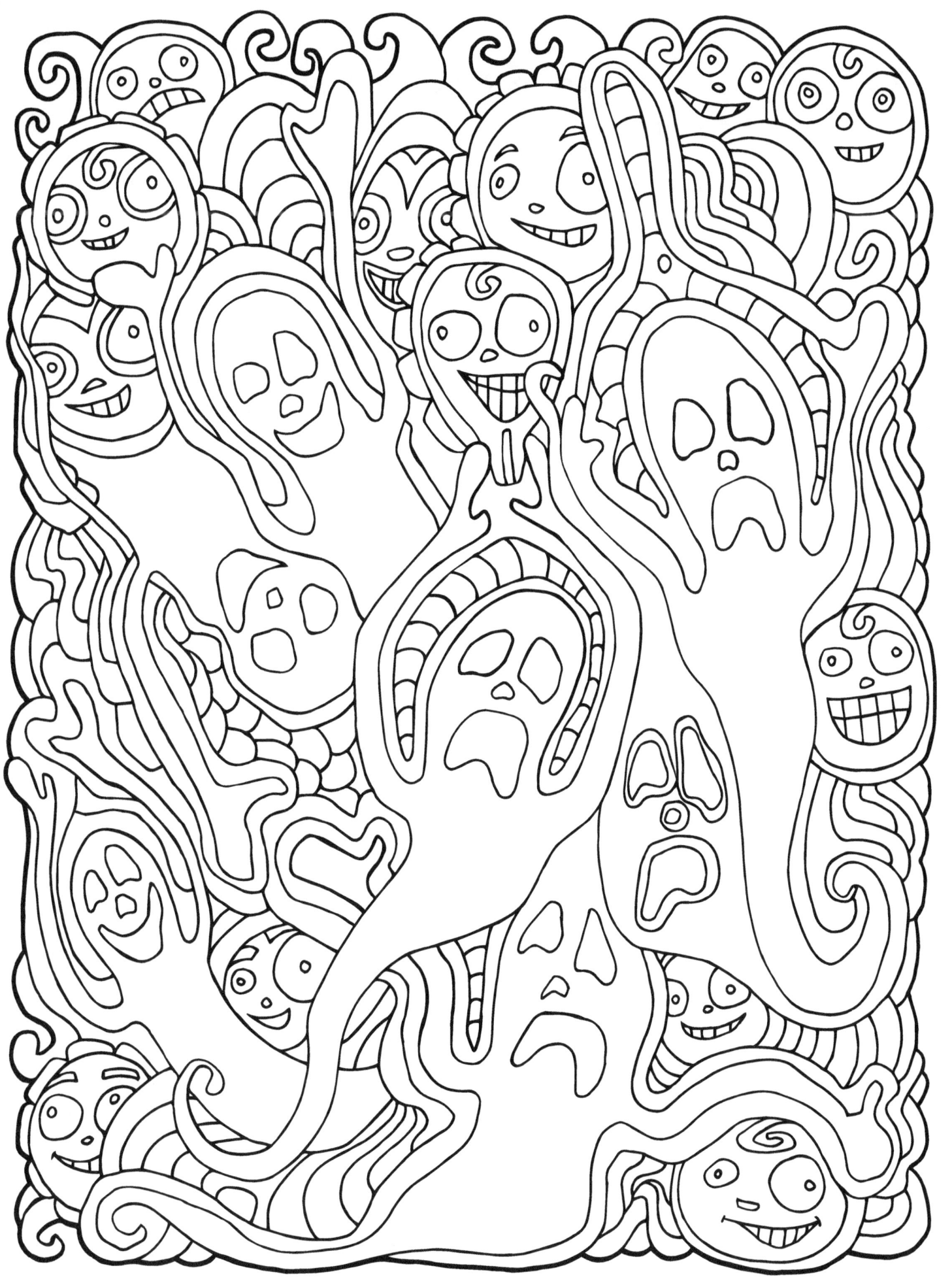

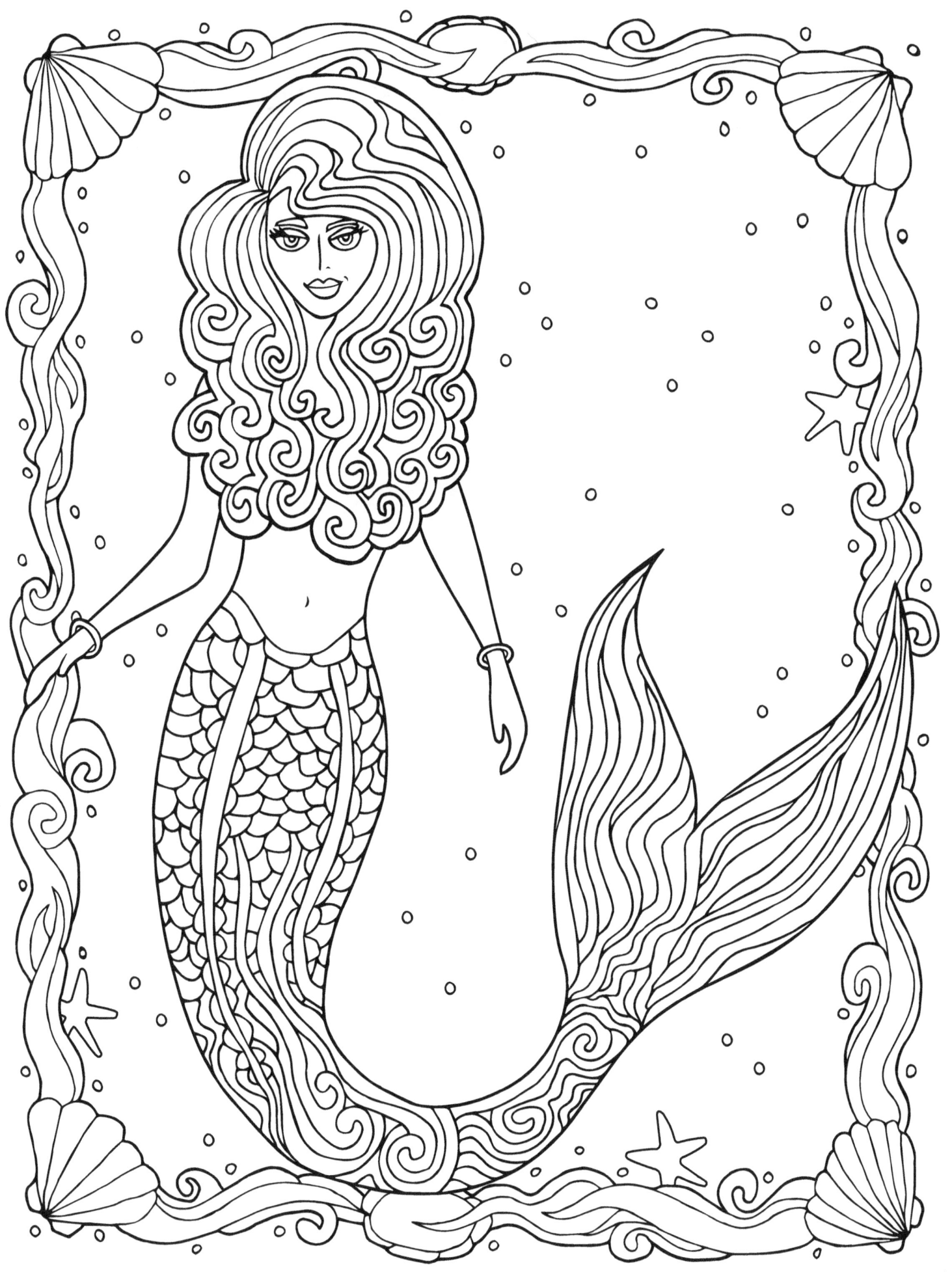

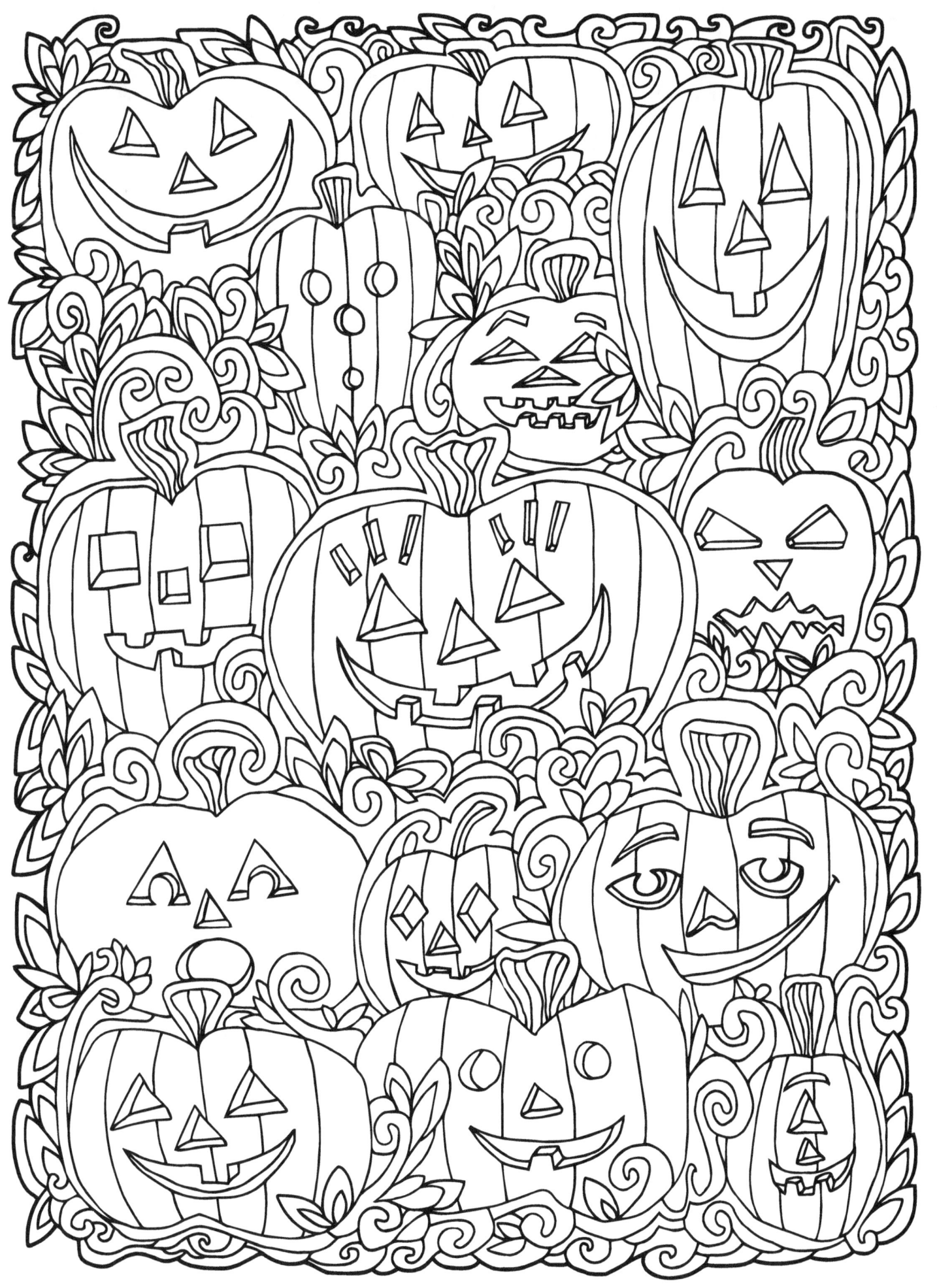

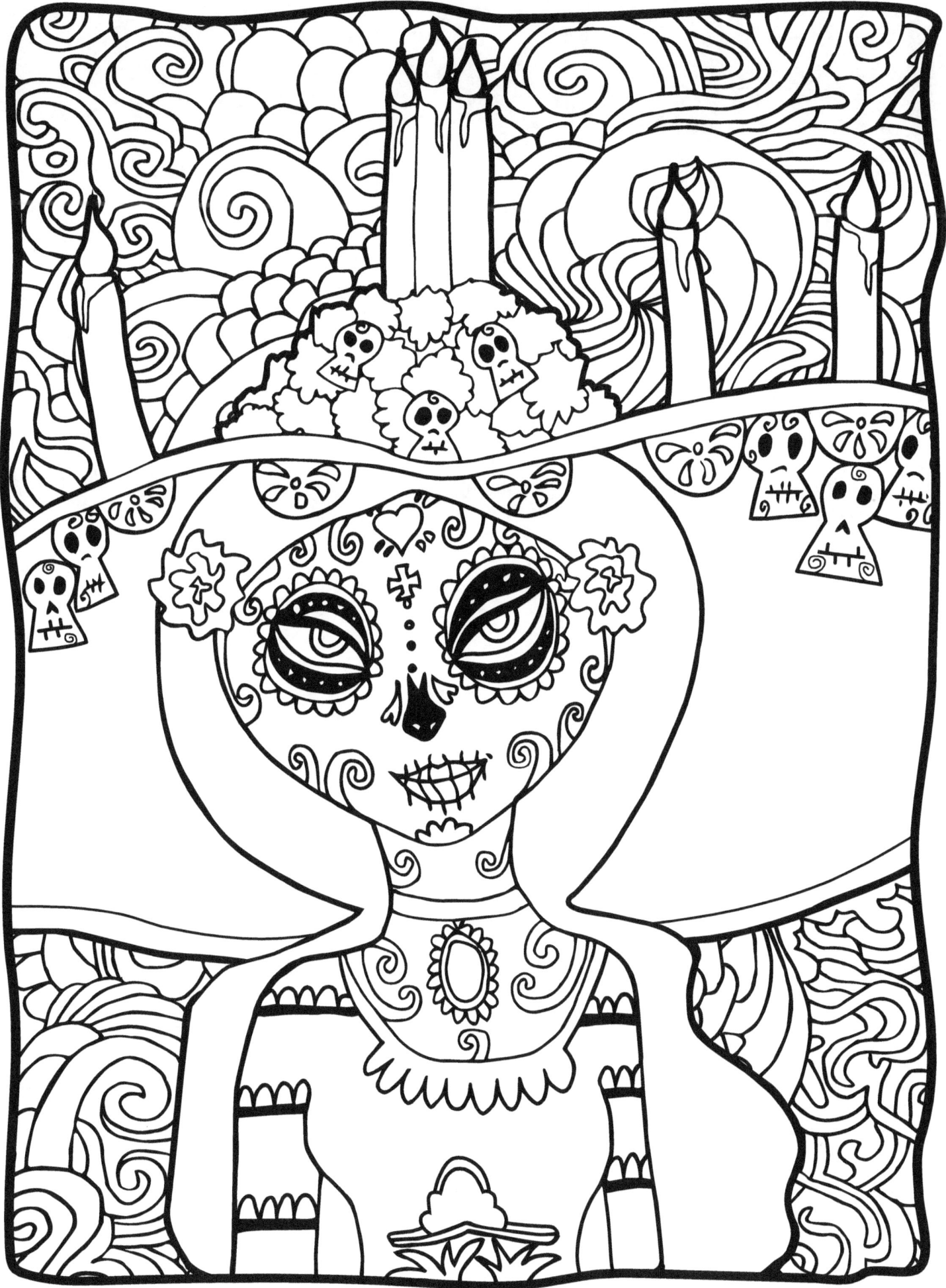

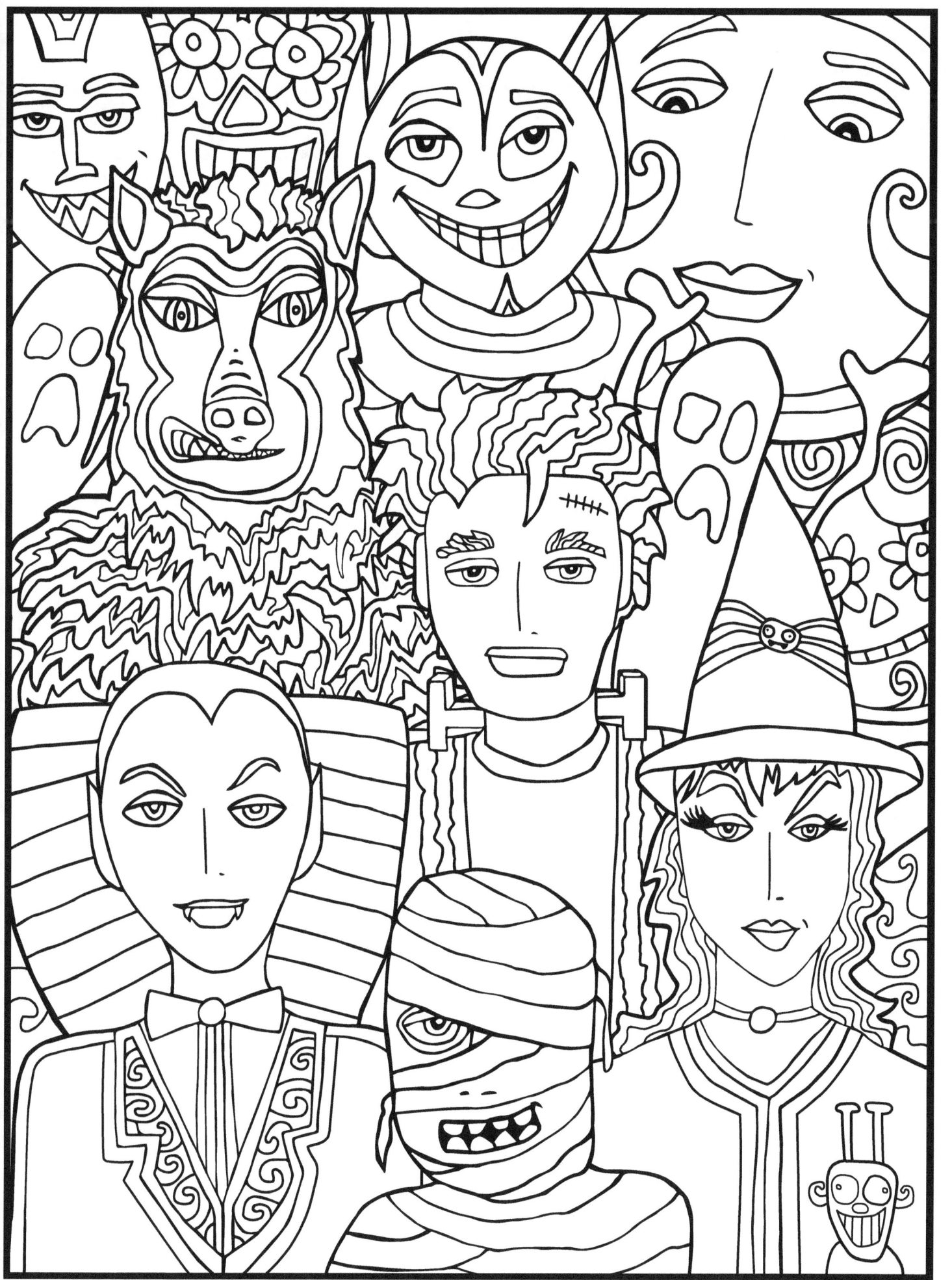

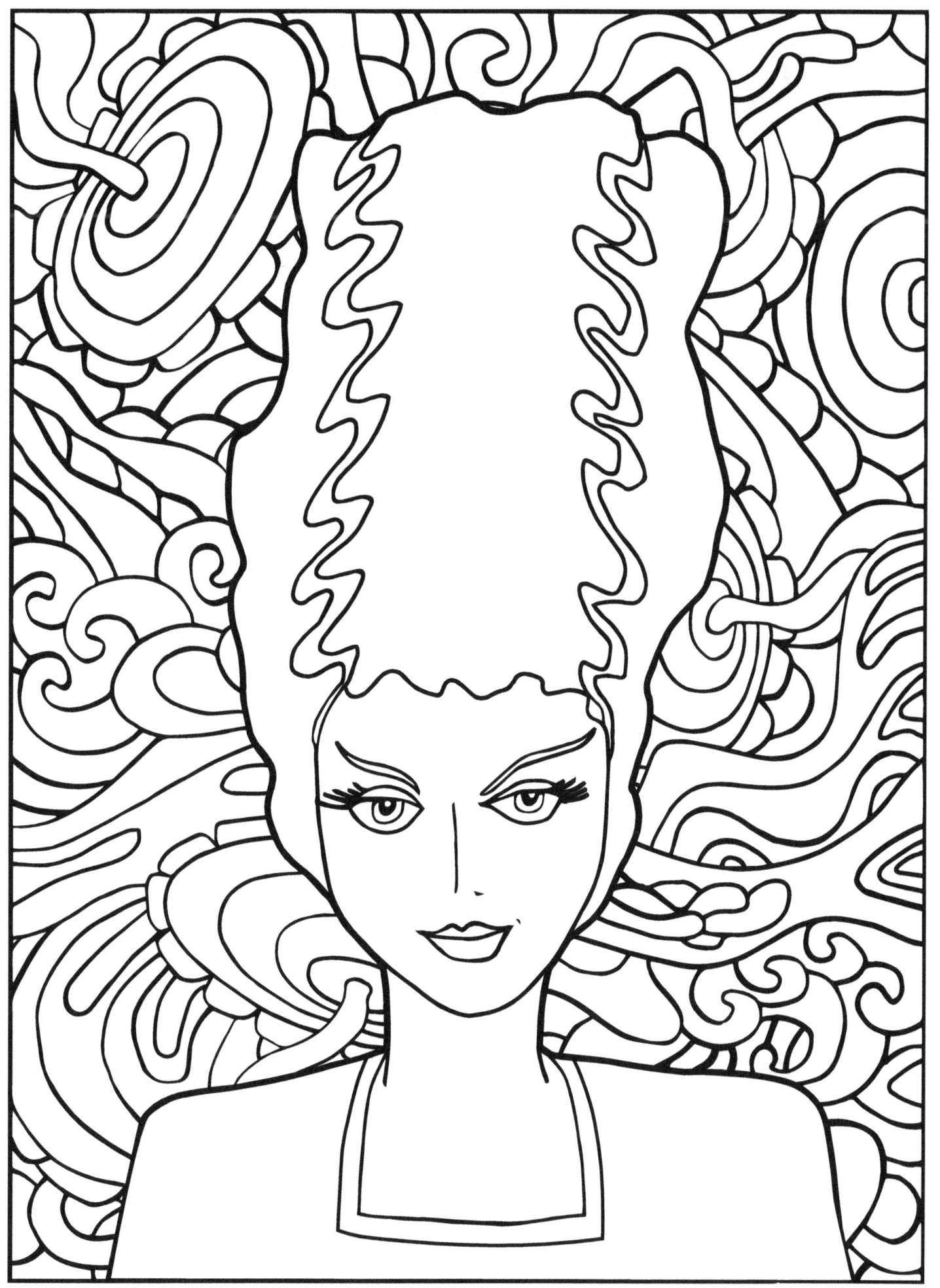

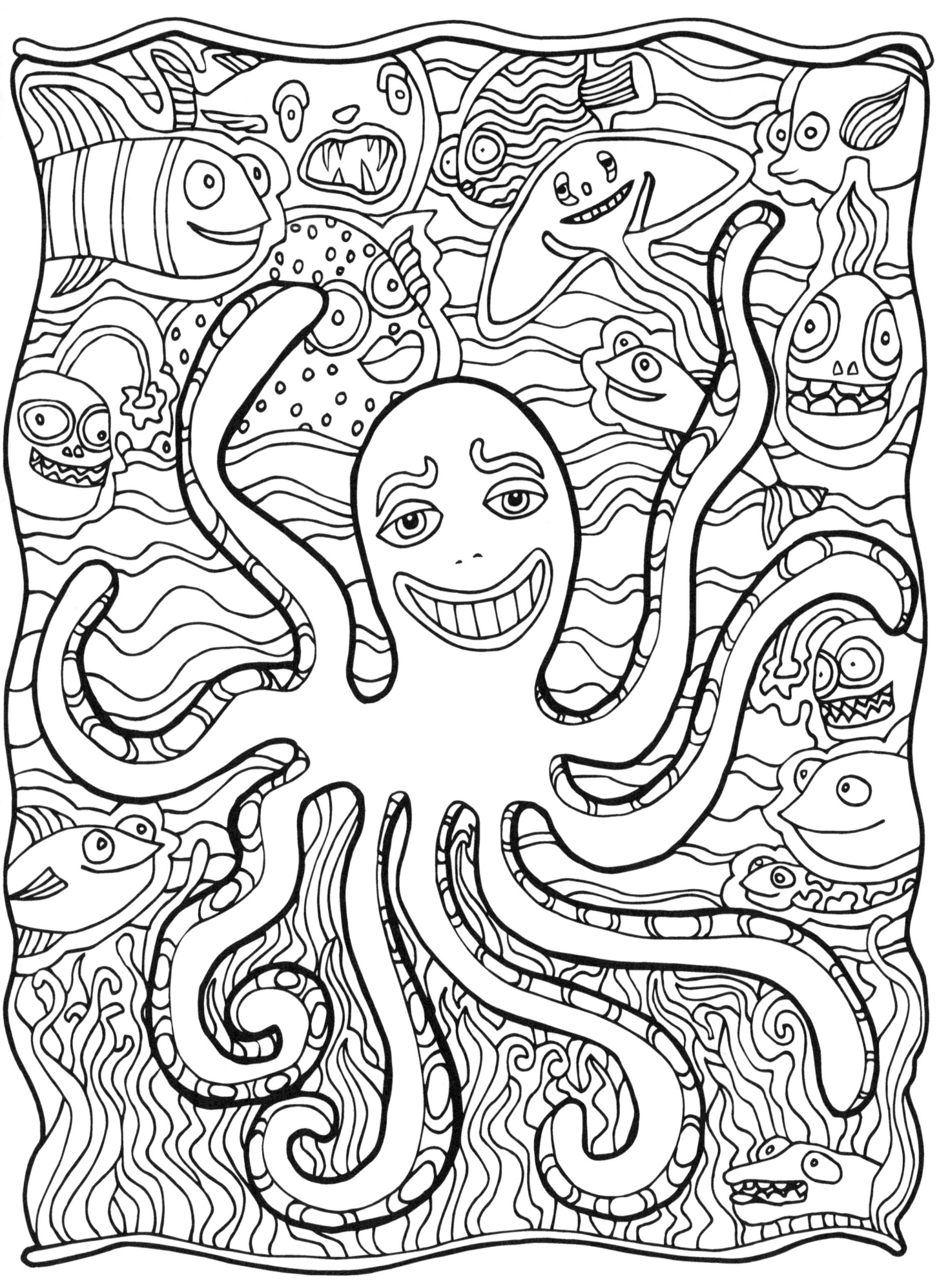

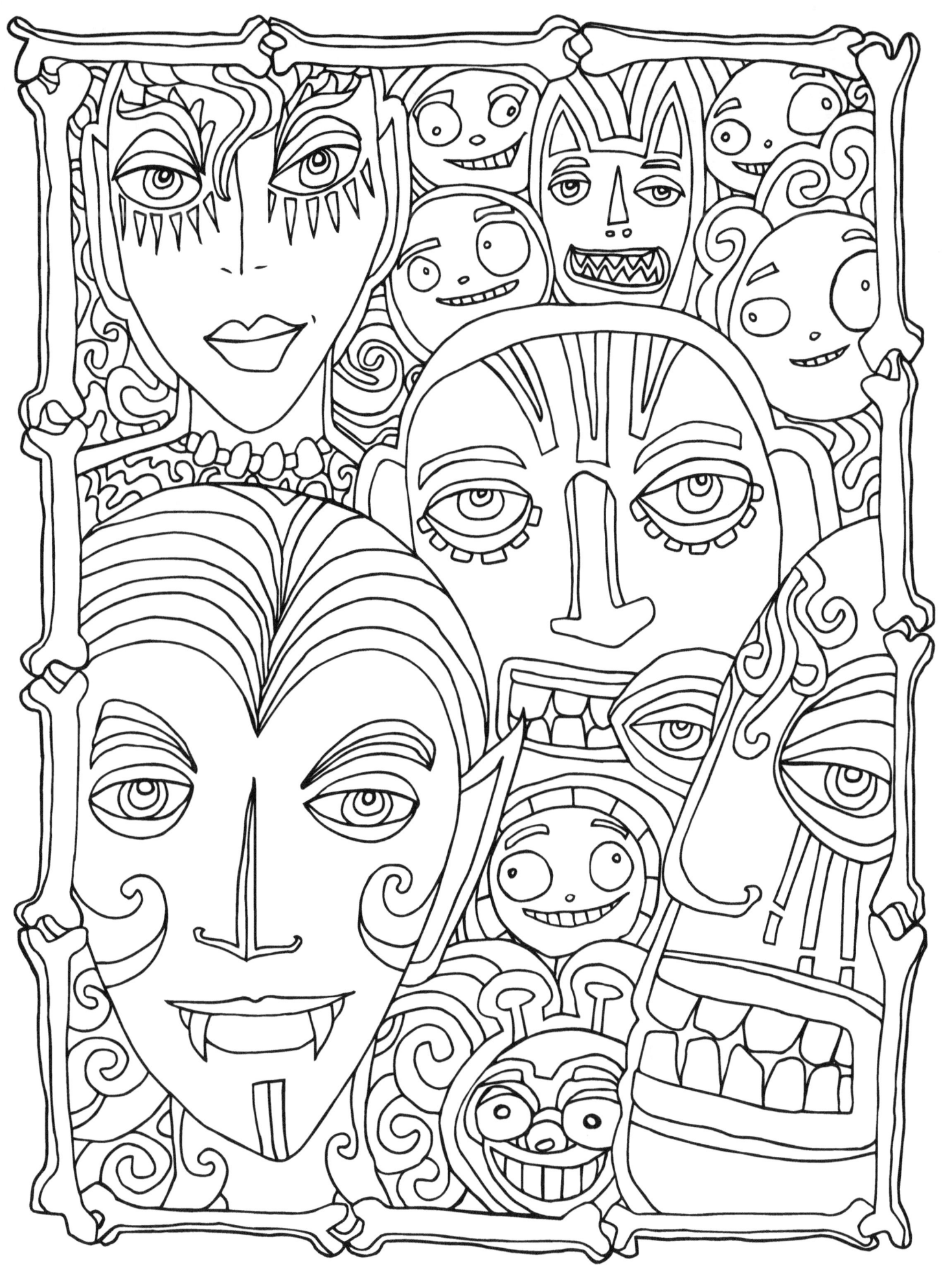

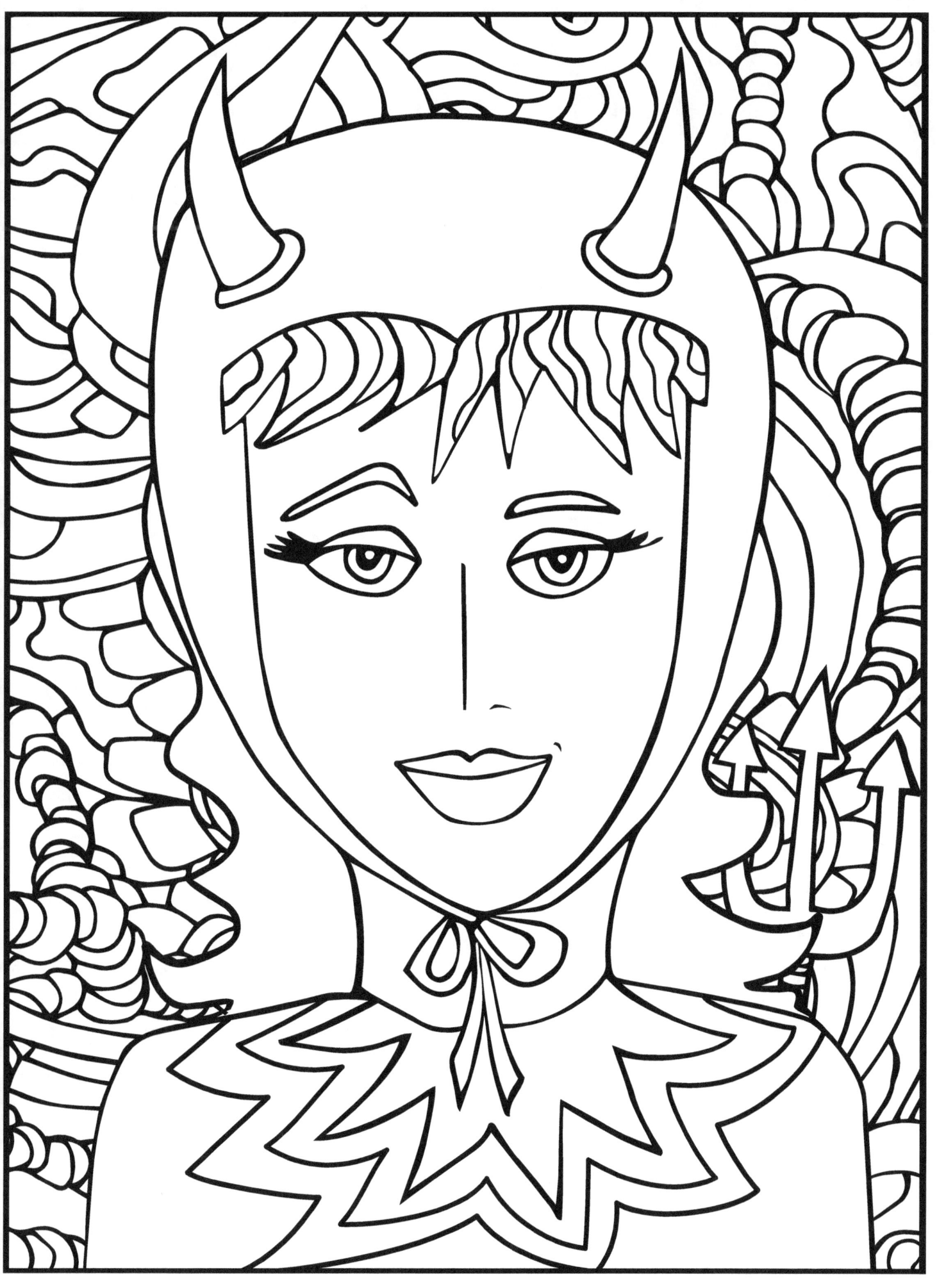

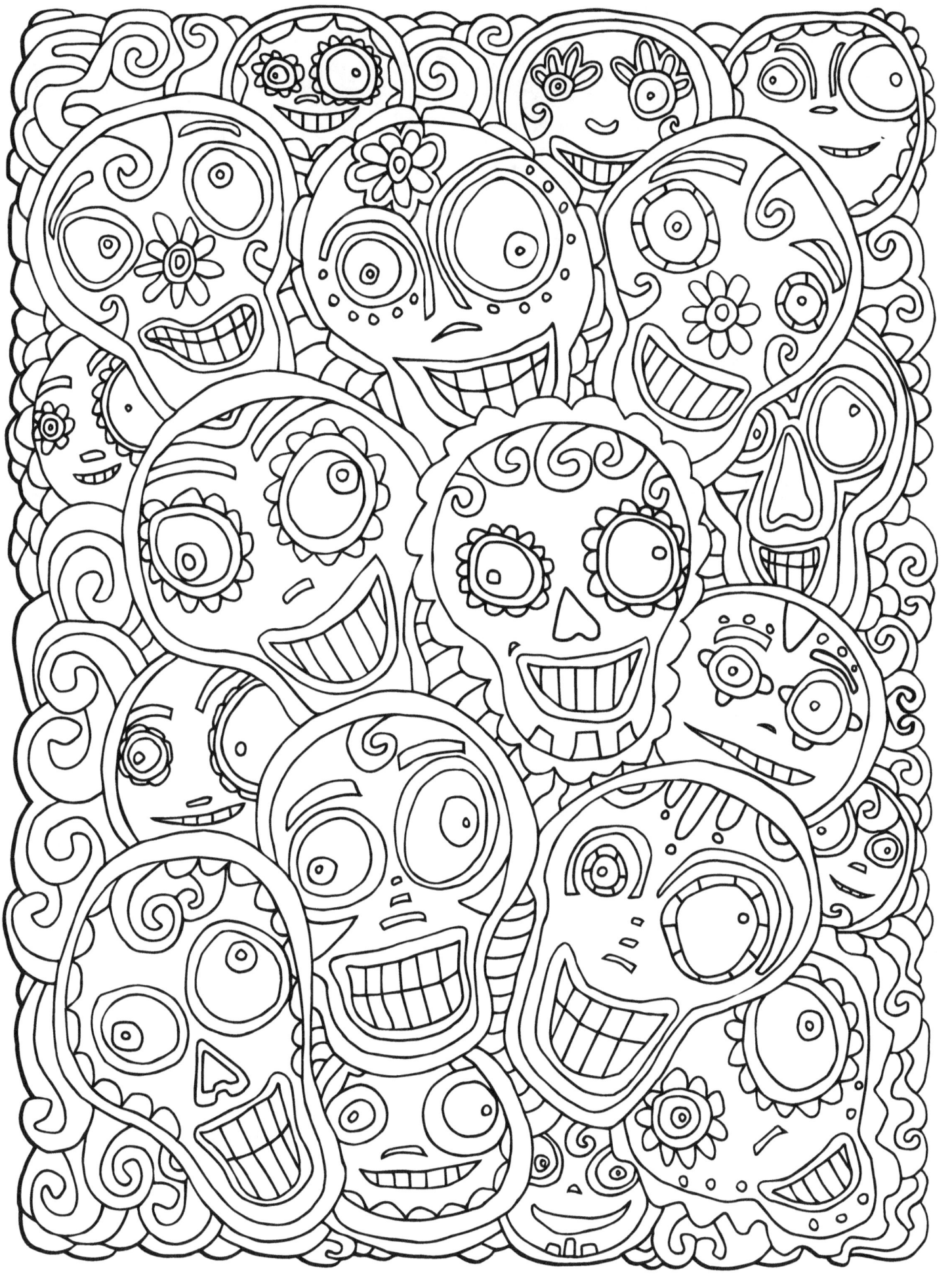

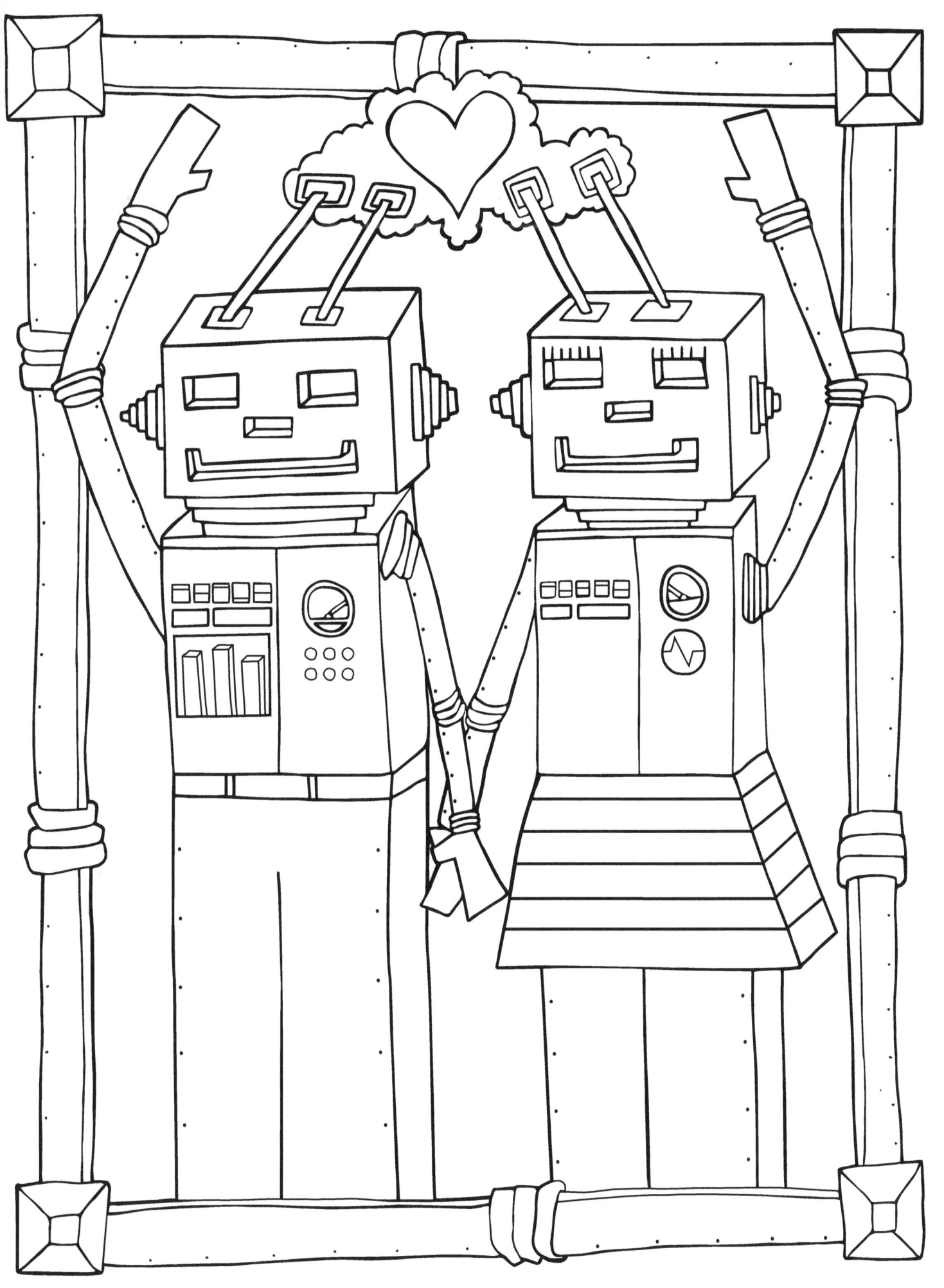

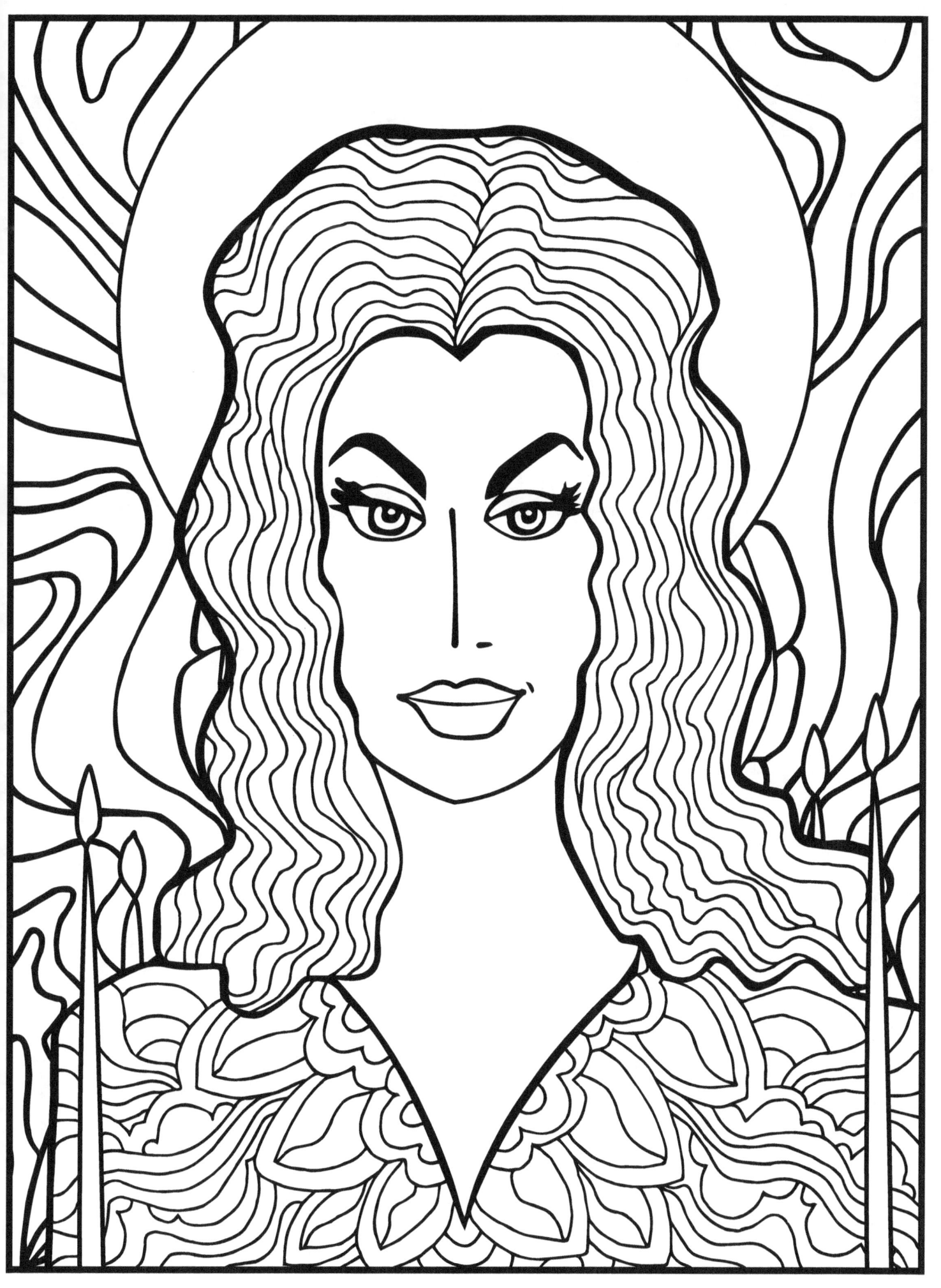

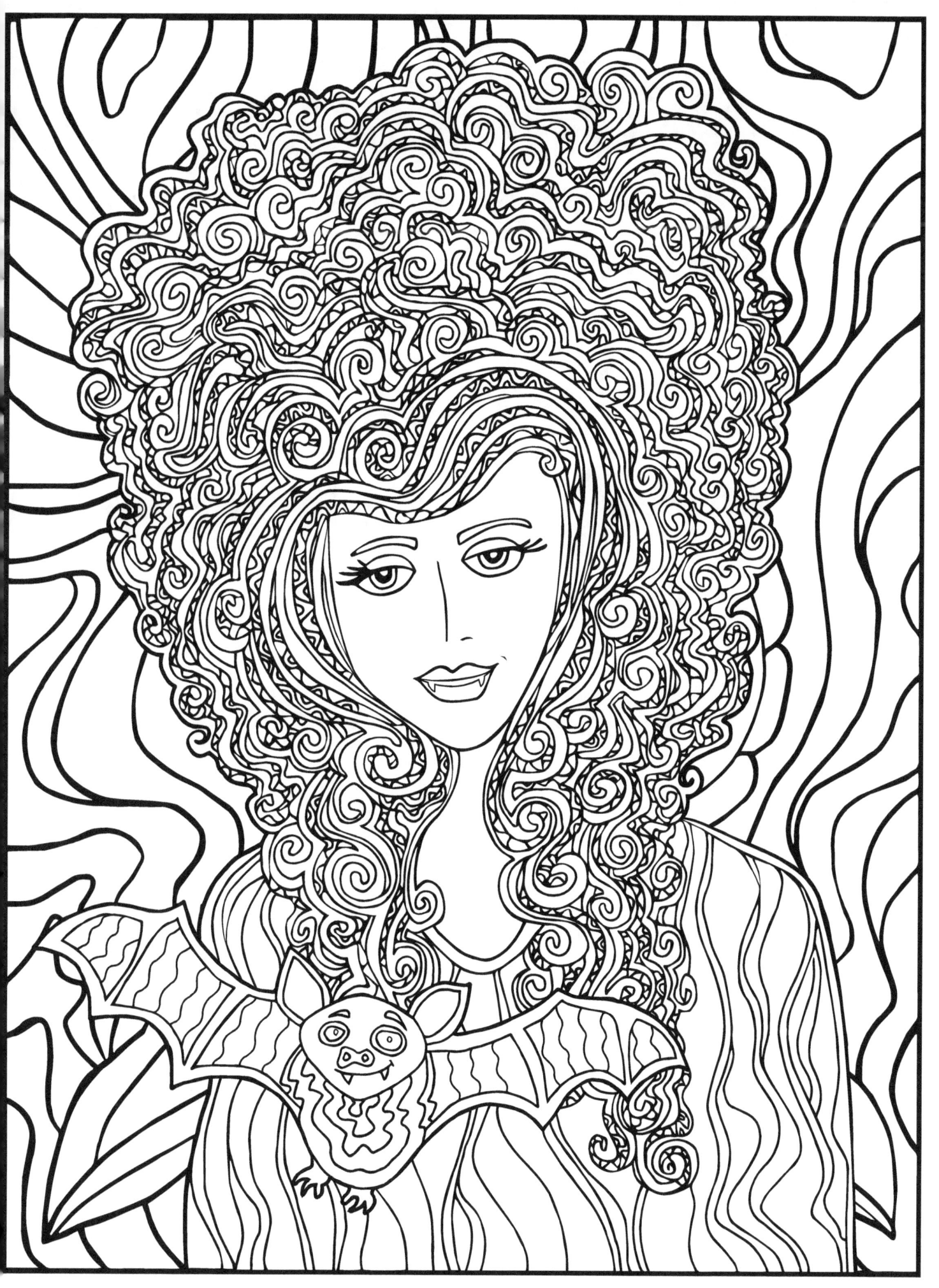

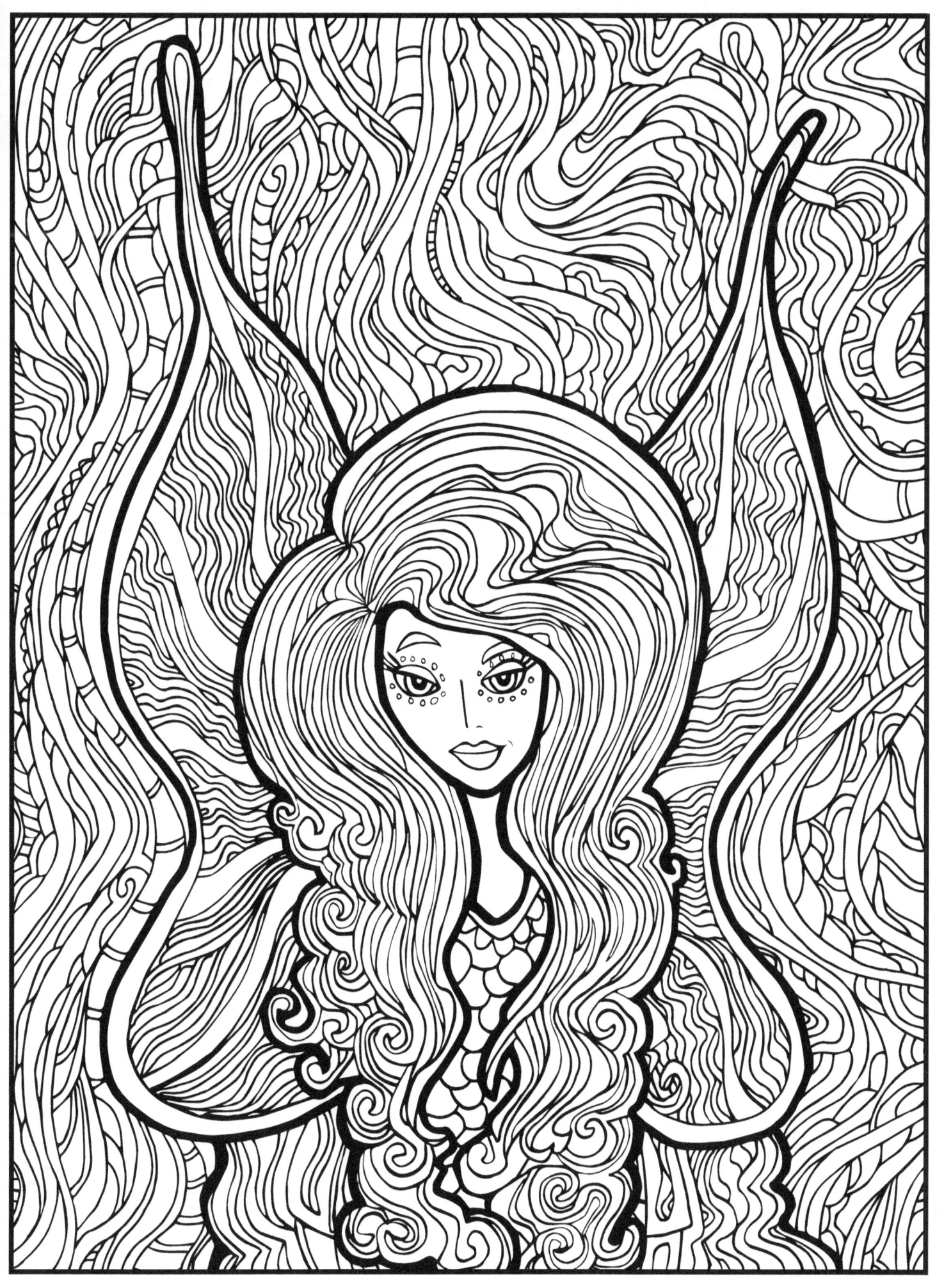

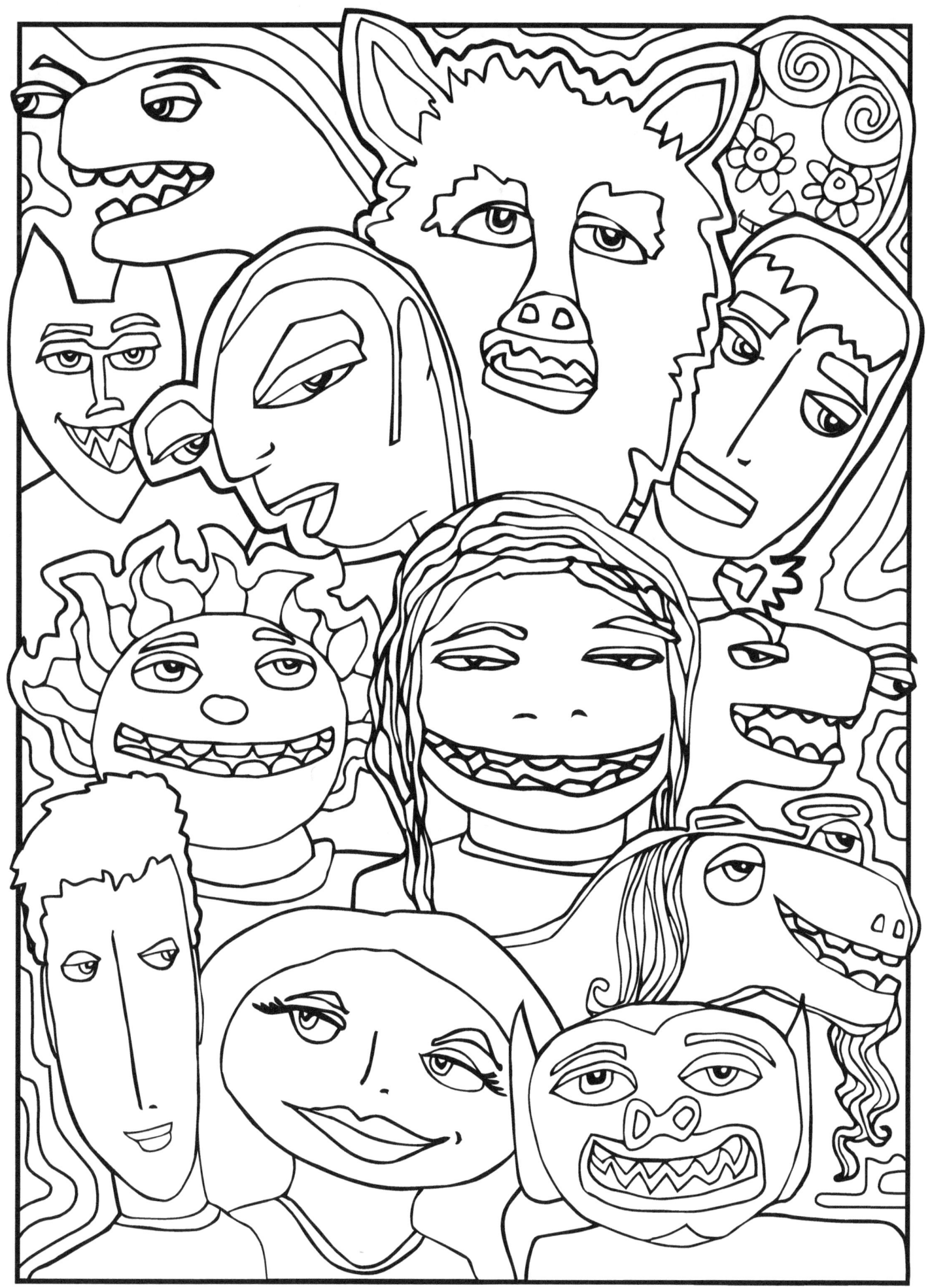

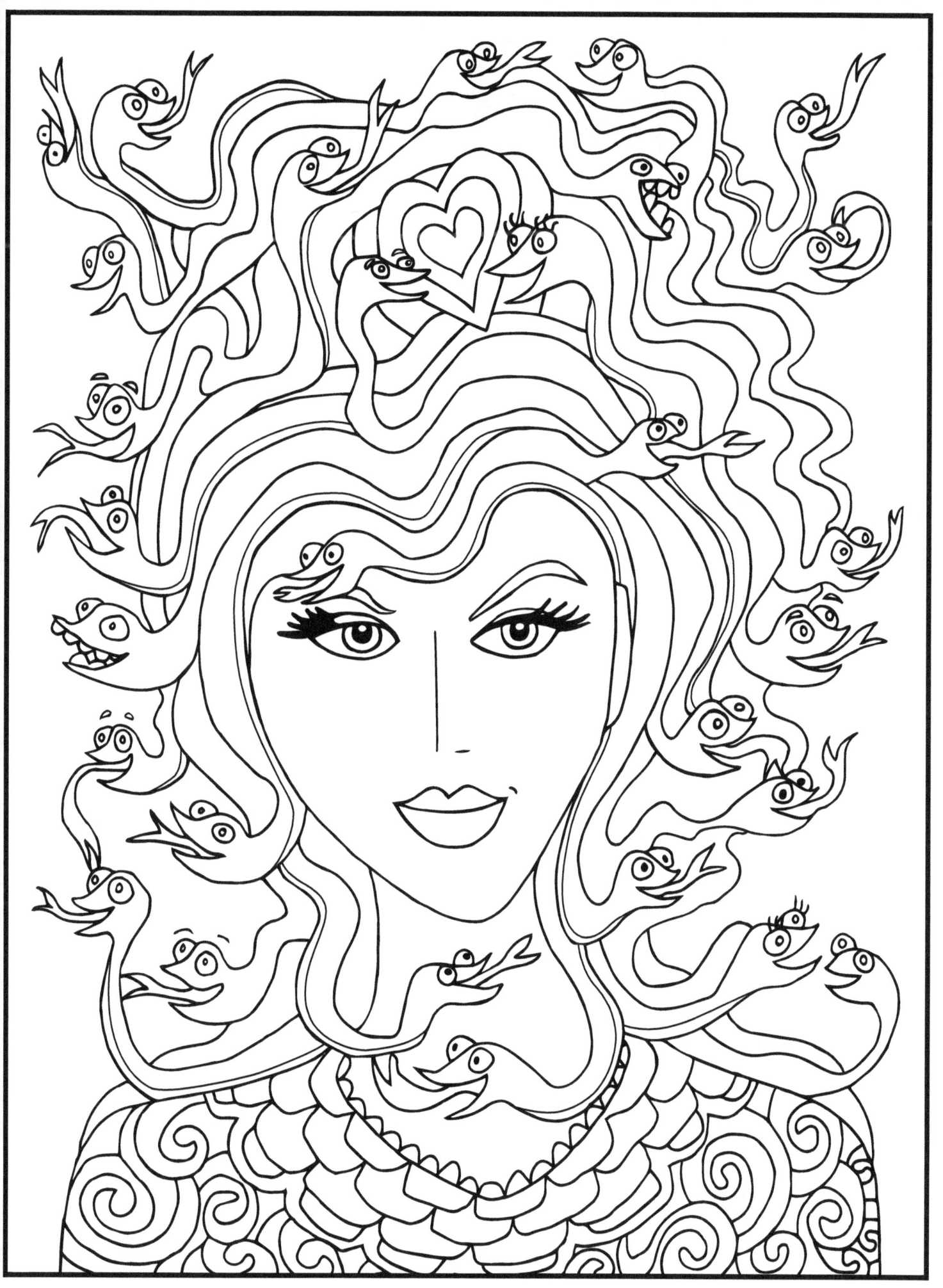

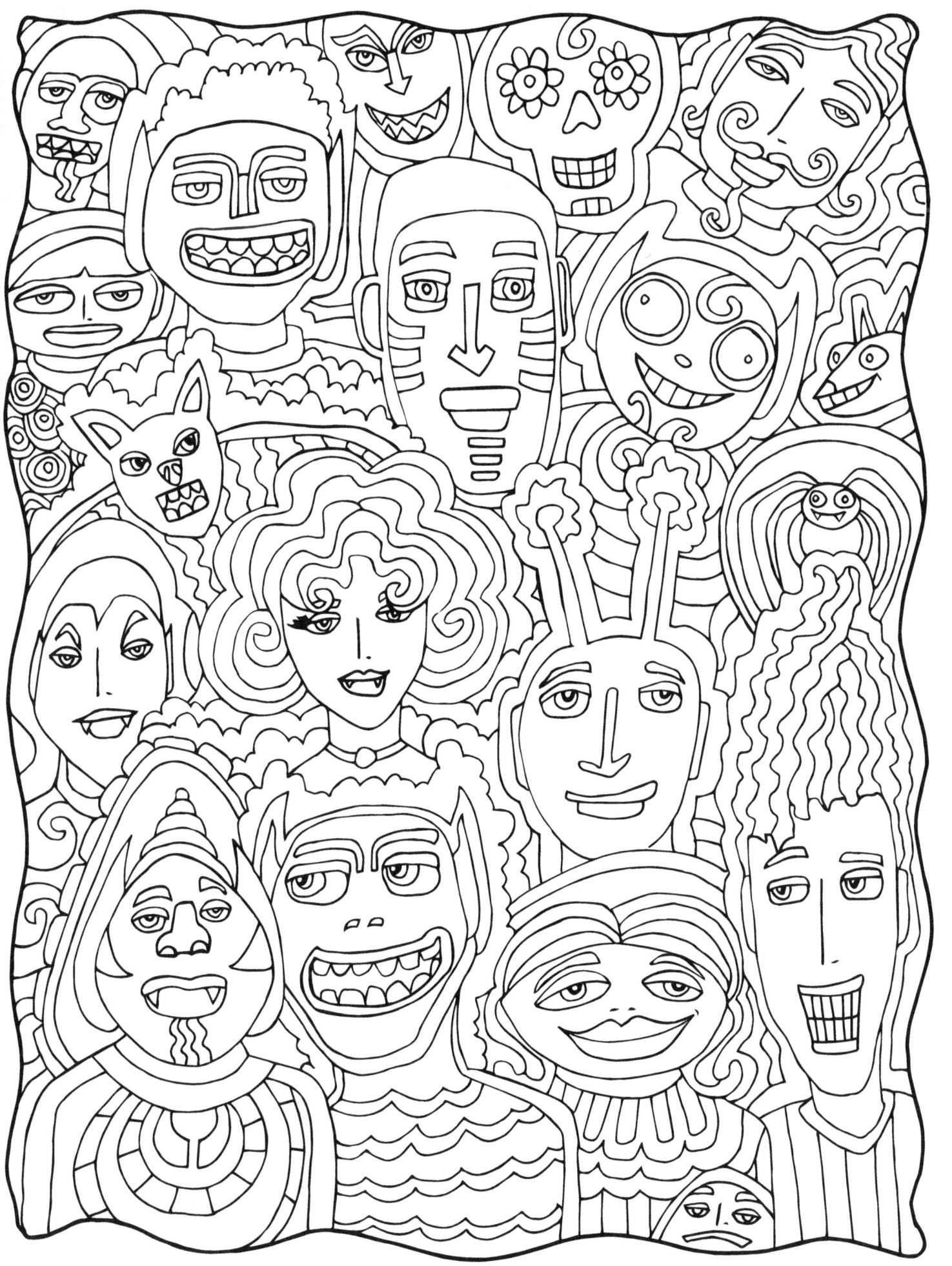

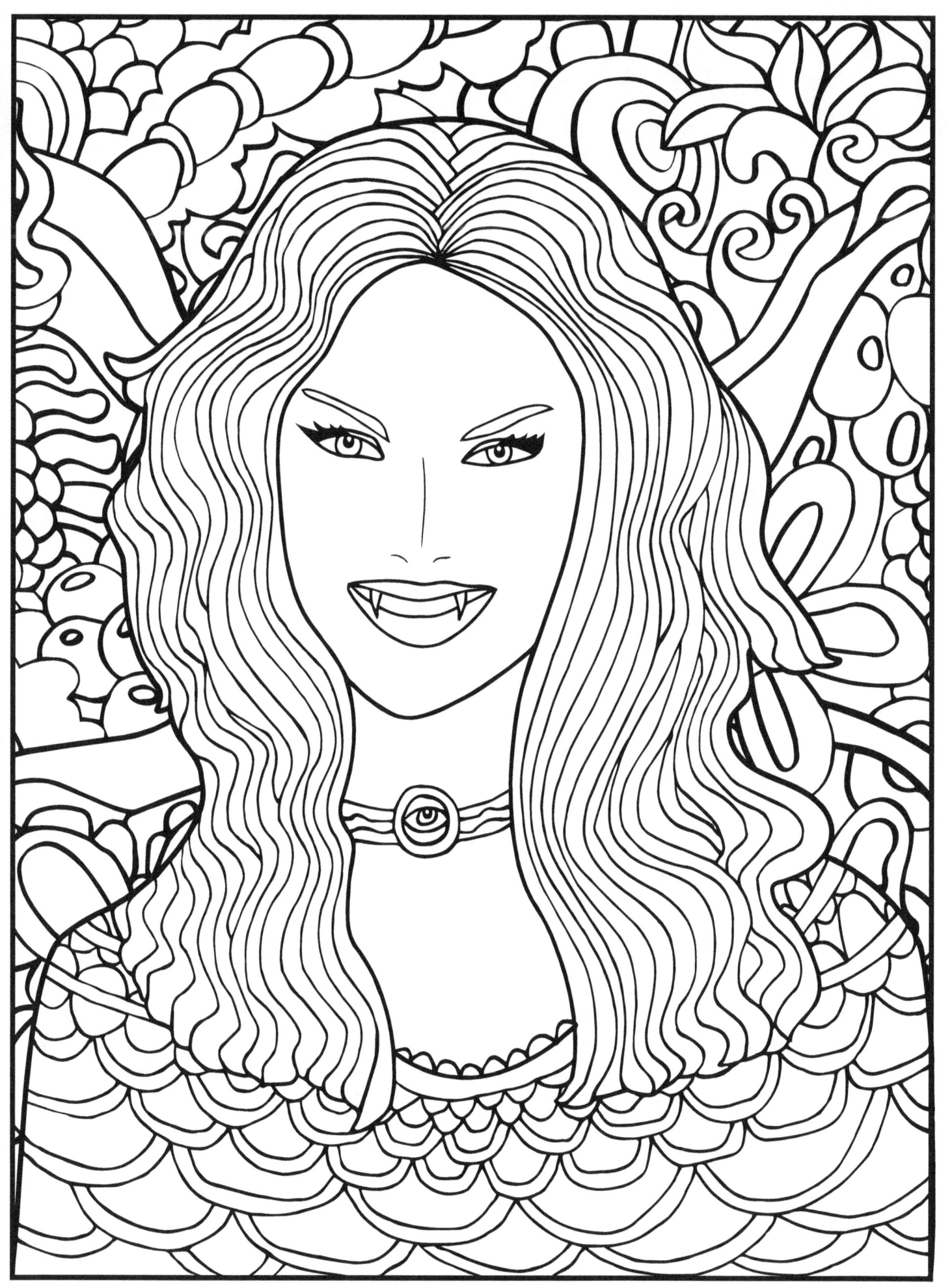

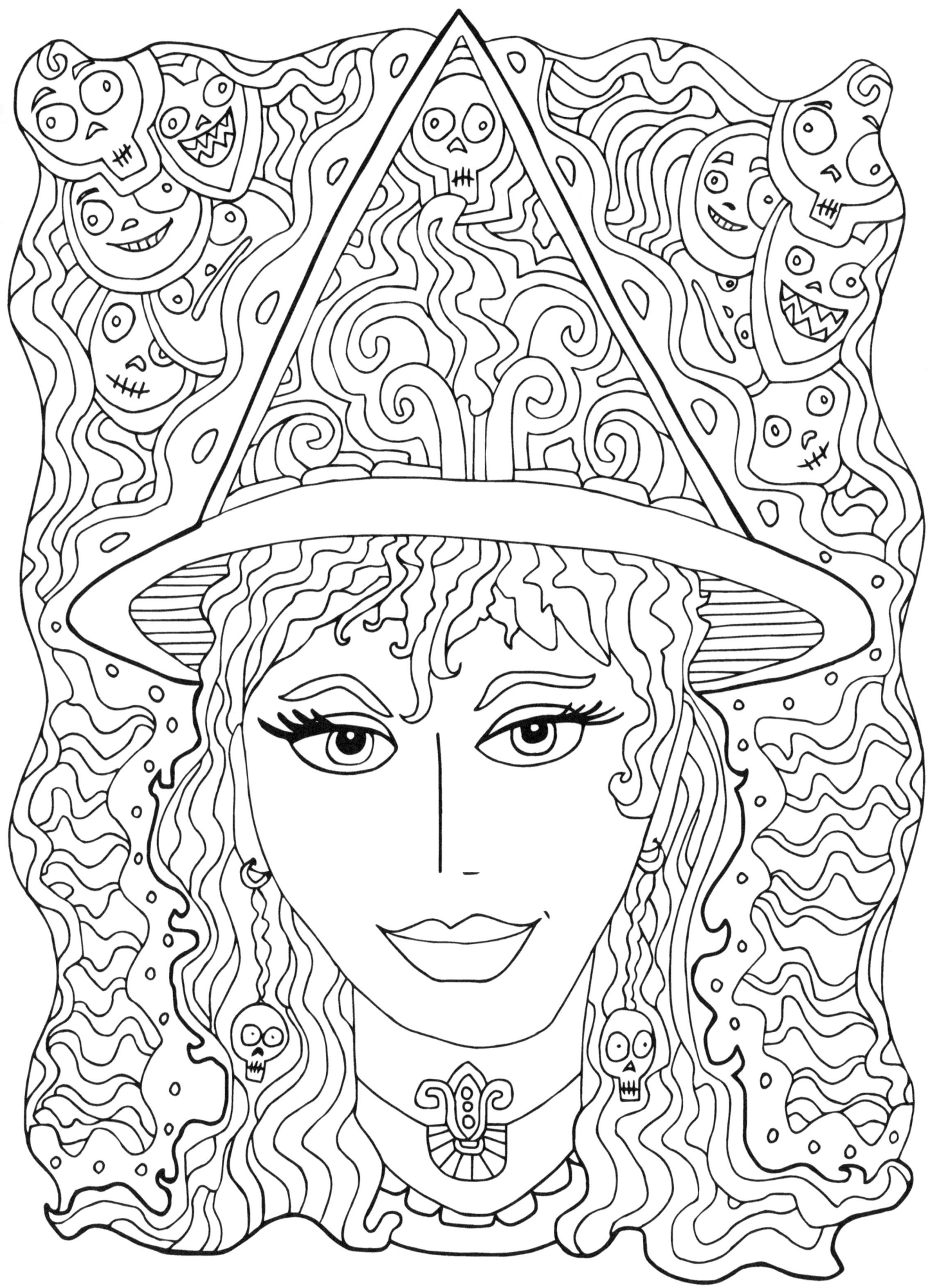

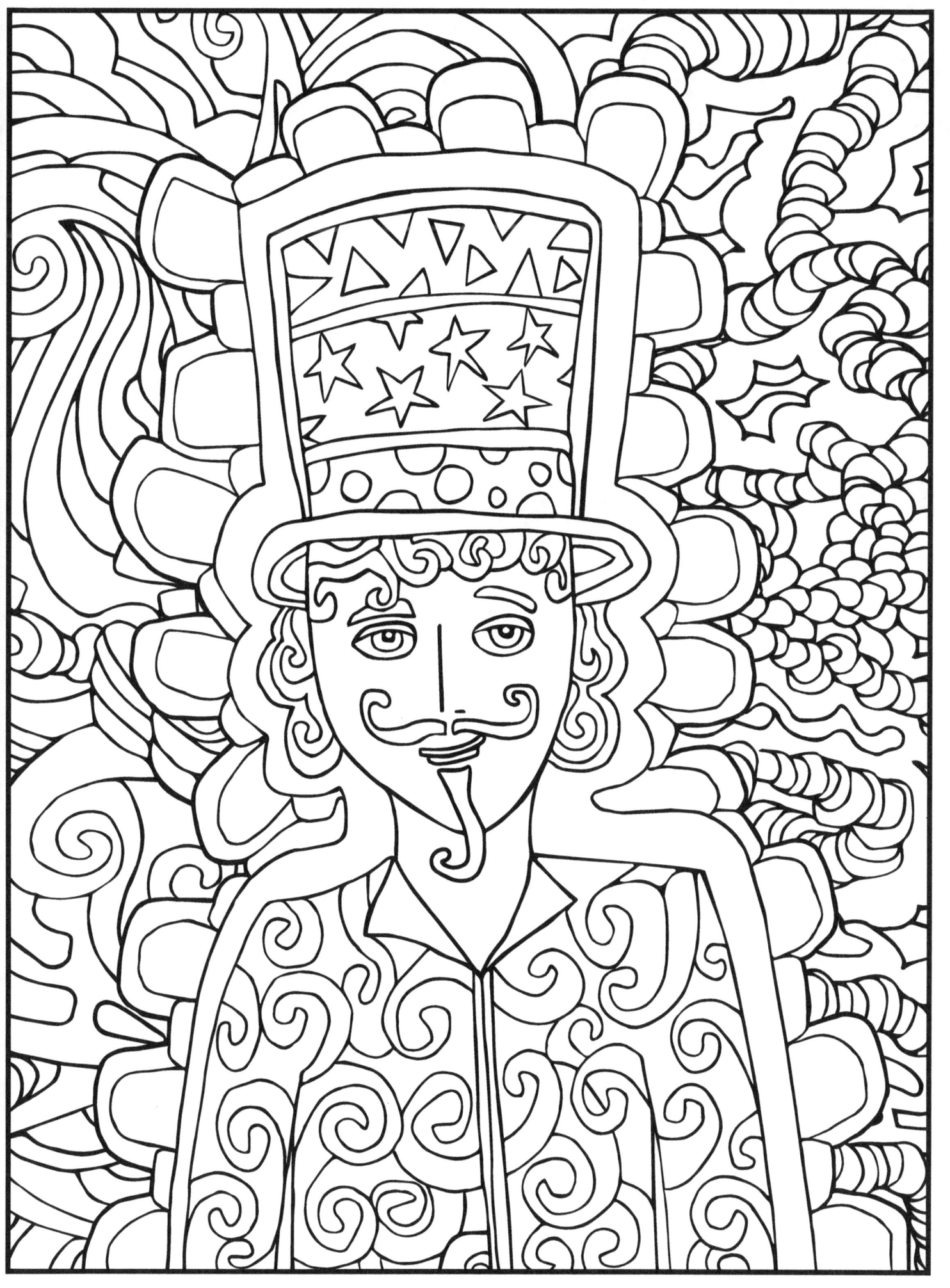

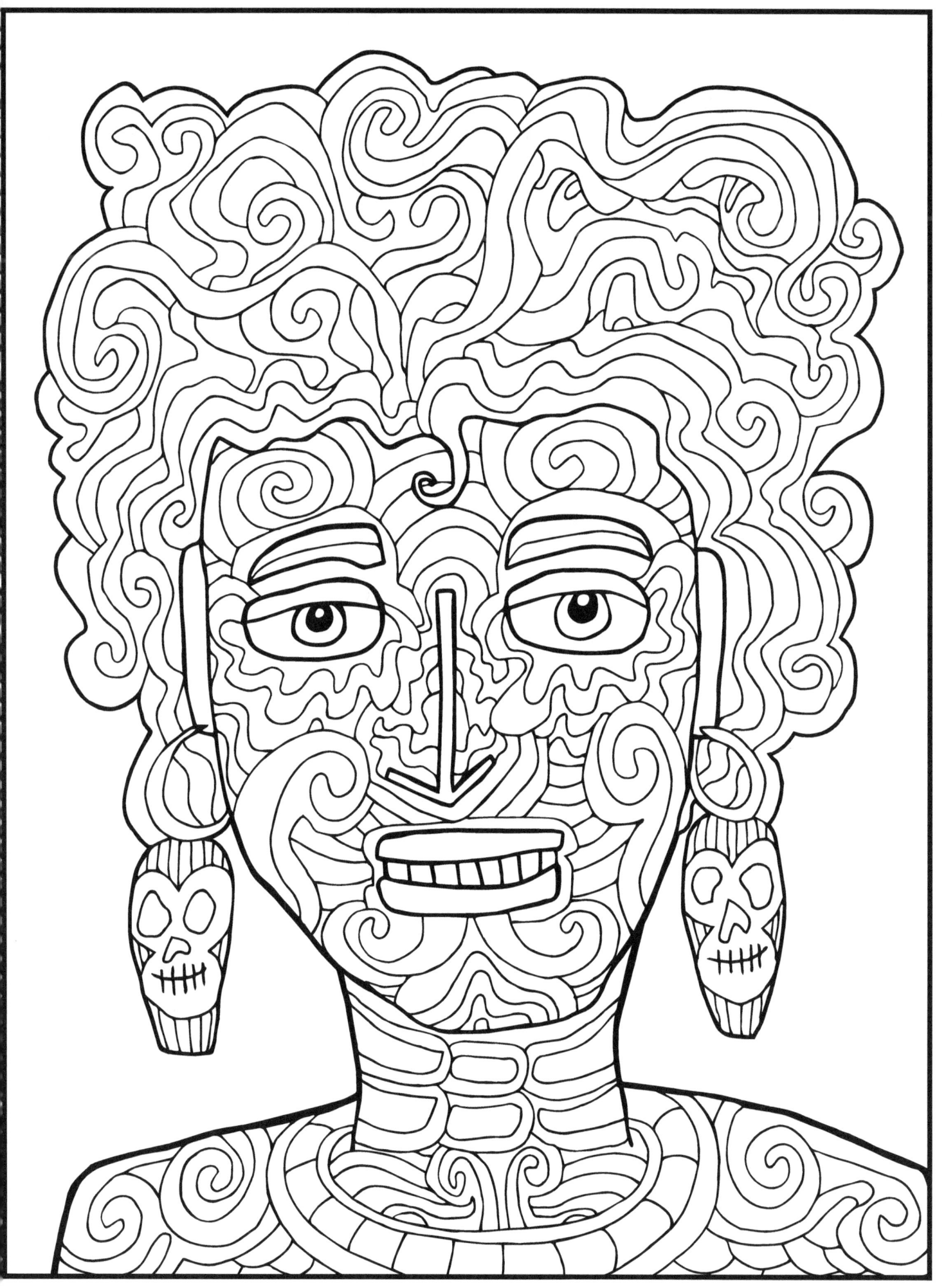

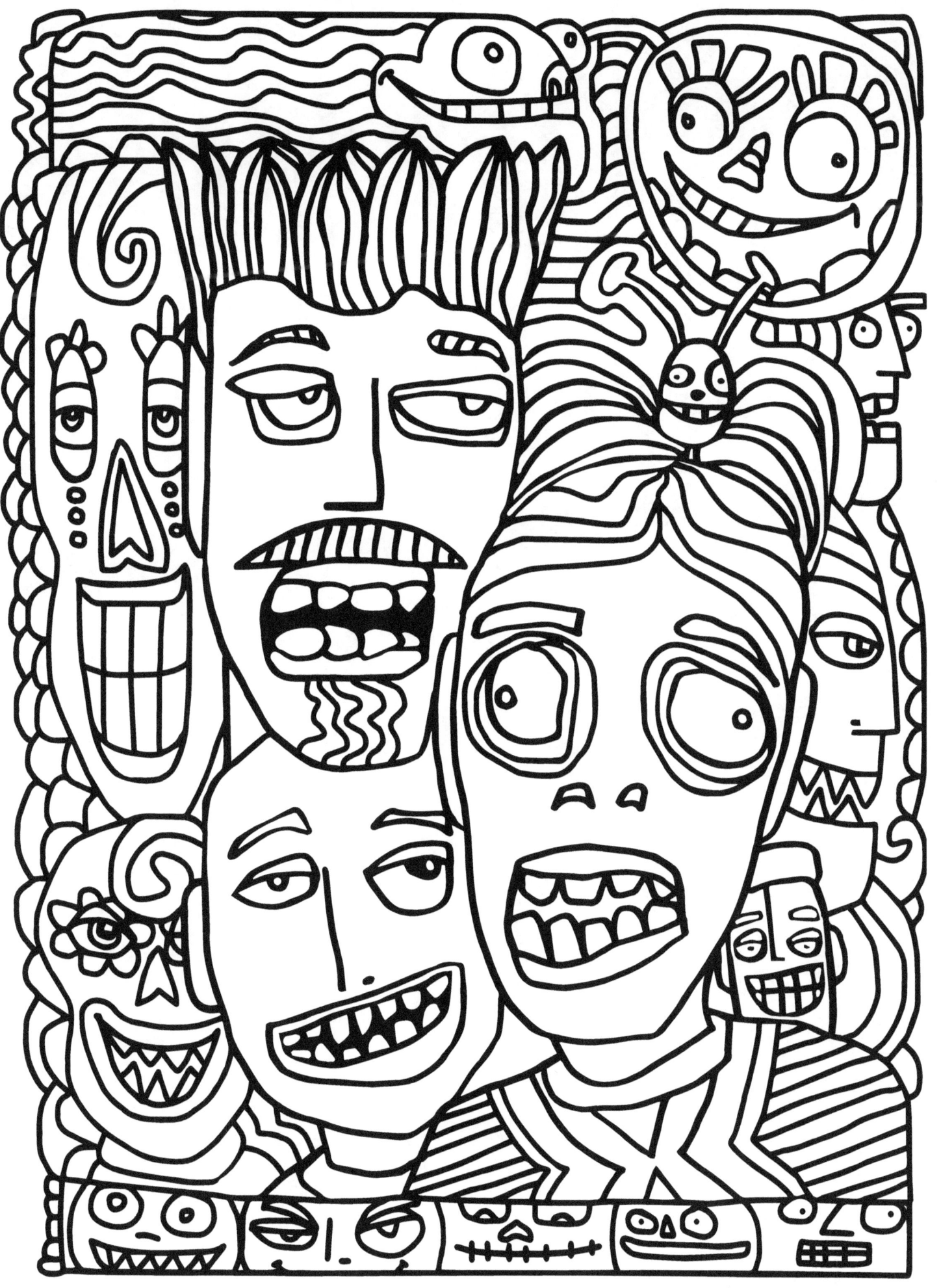